CREEPY CRAWLIES COLOURING BOOK

COPYRIGHT PAUL McGRATH
2019

Instagram.com/paulmcgrath820/

LOUD LARVAE

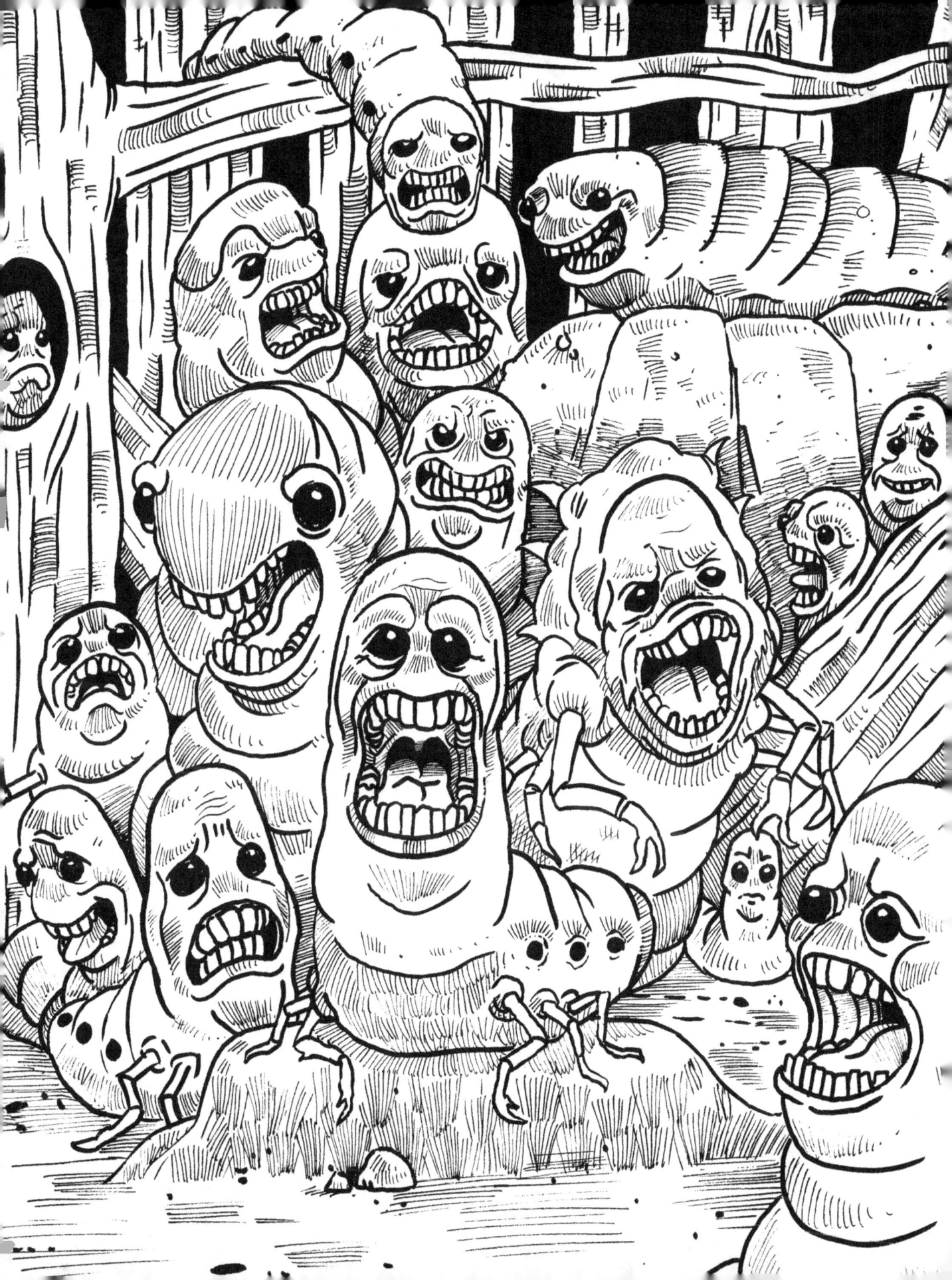

CANNIBAL CRICKETS

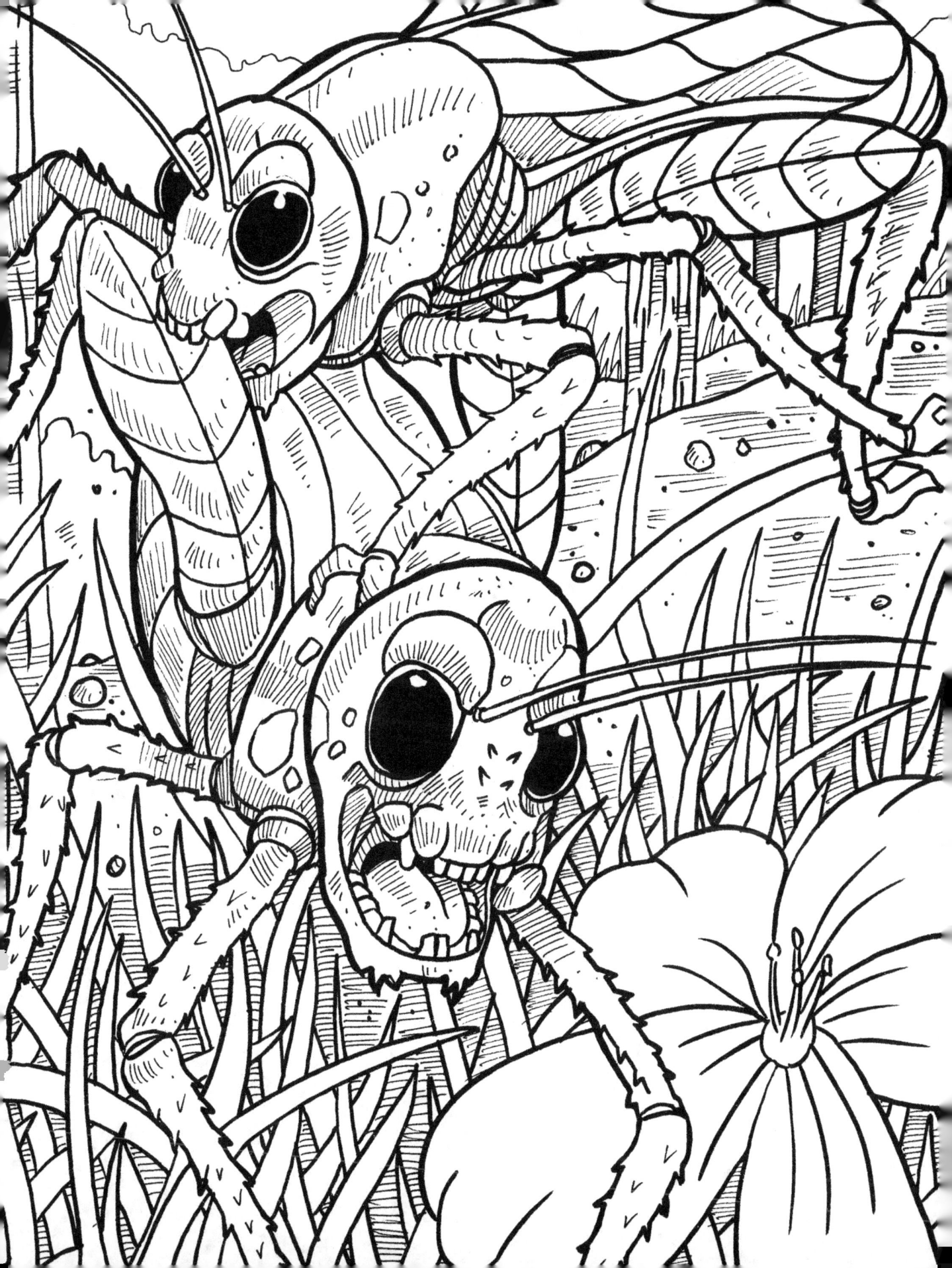

EGREGIOUS ARACHNID

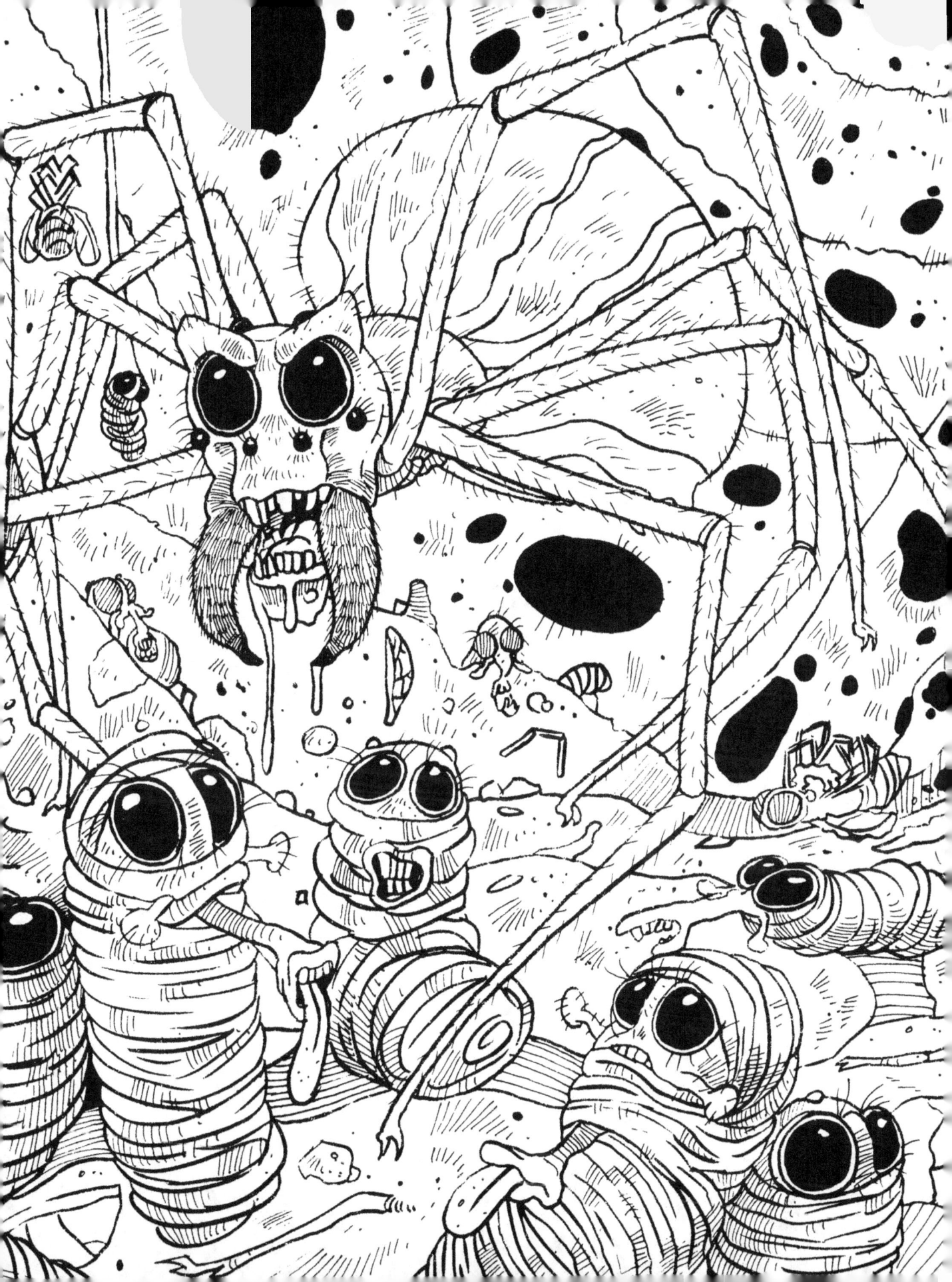

MACABRE MANTIS

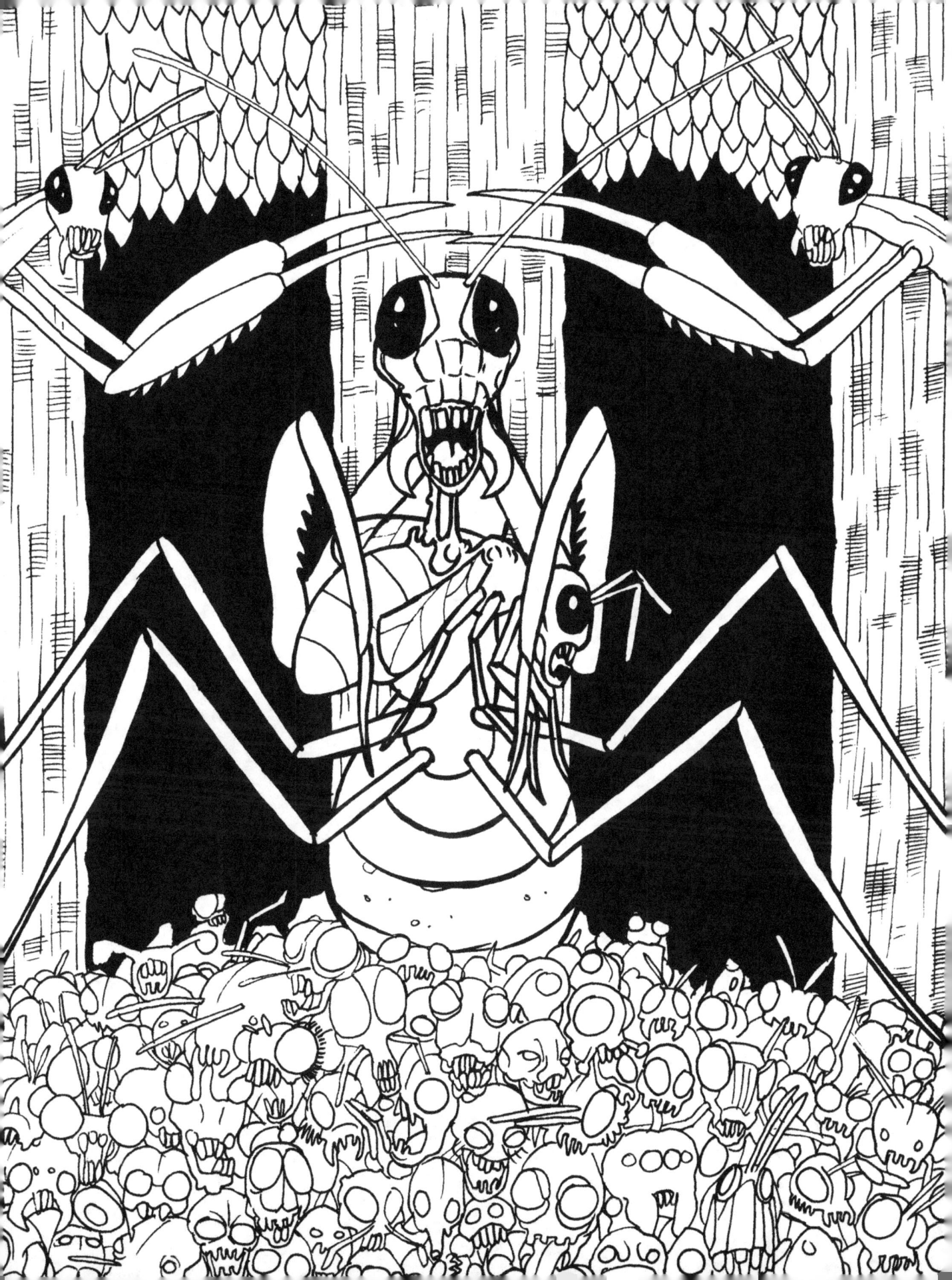

SICKENING SCORPION

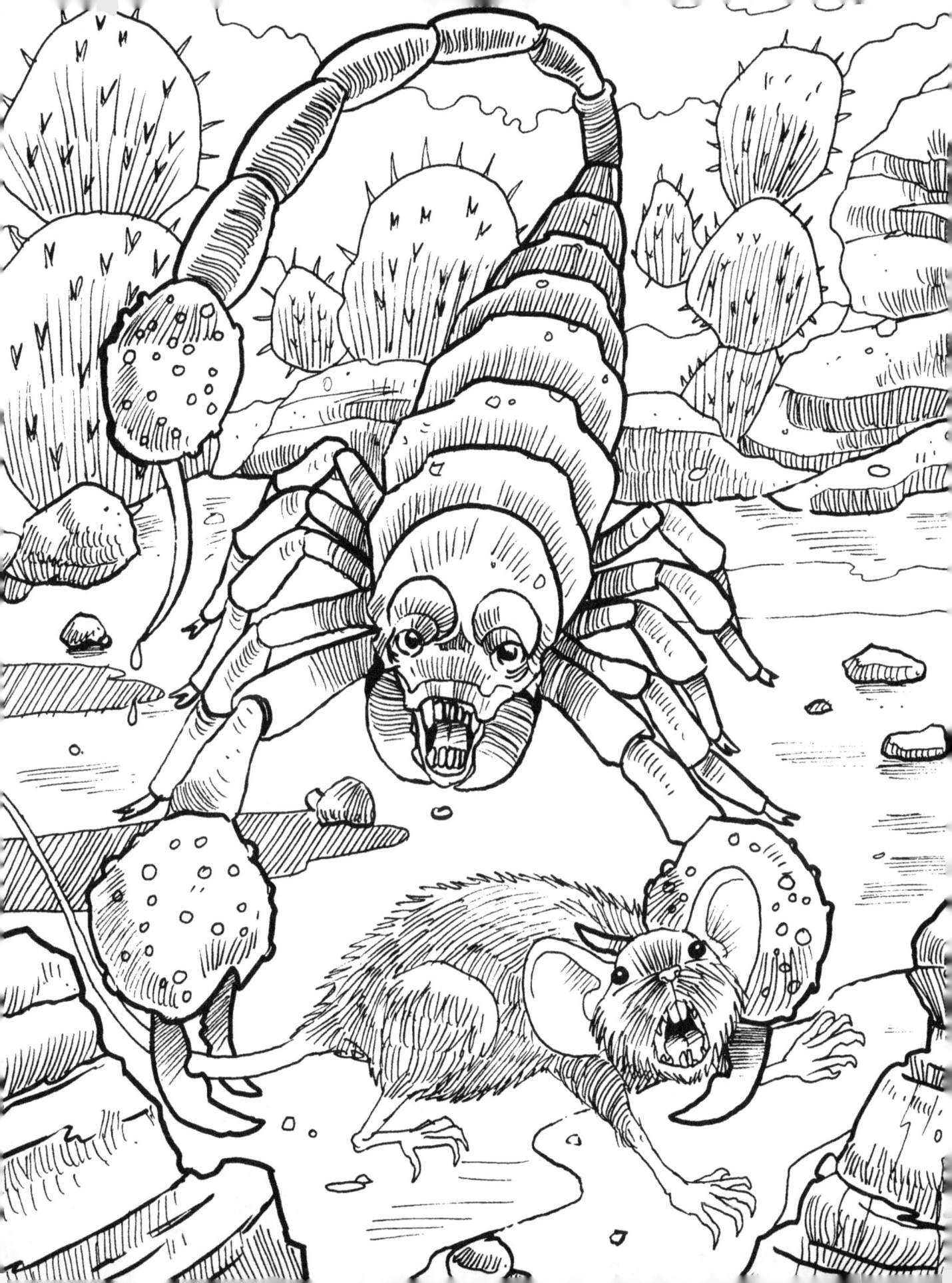

WRETCHED WOODLICE

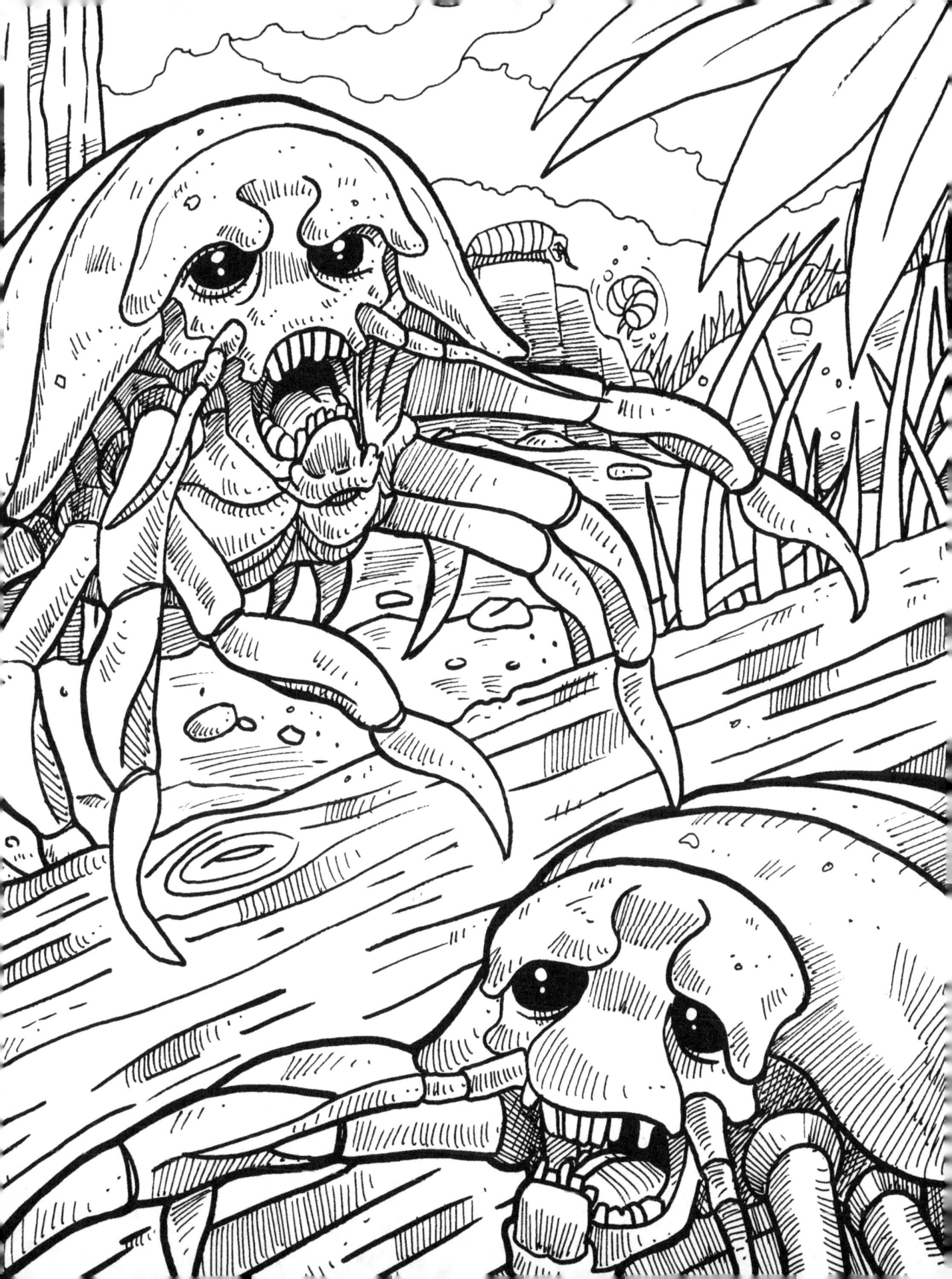

BLASTER BOMBADIER

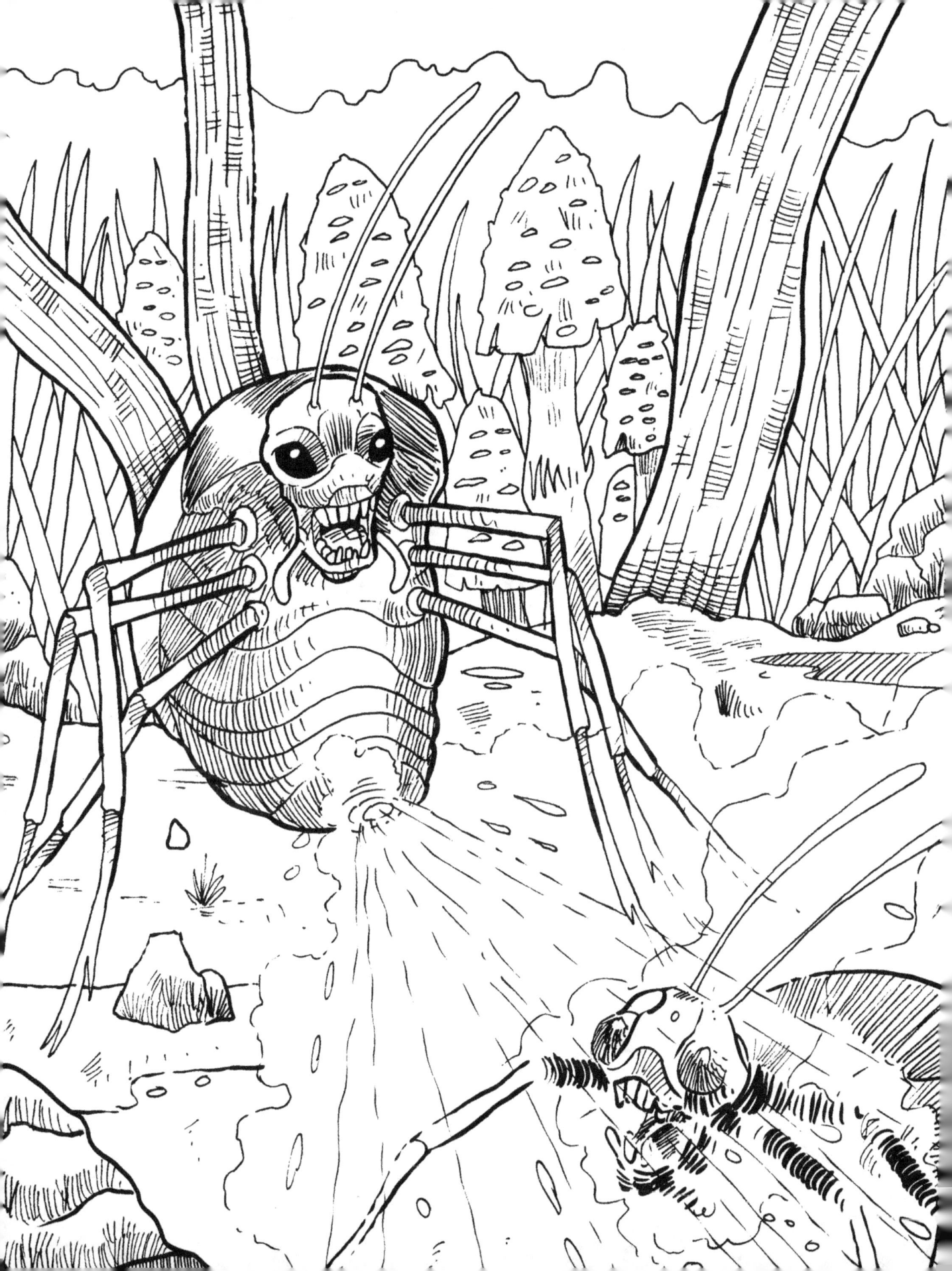

CRANKY COCOON

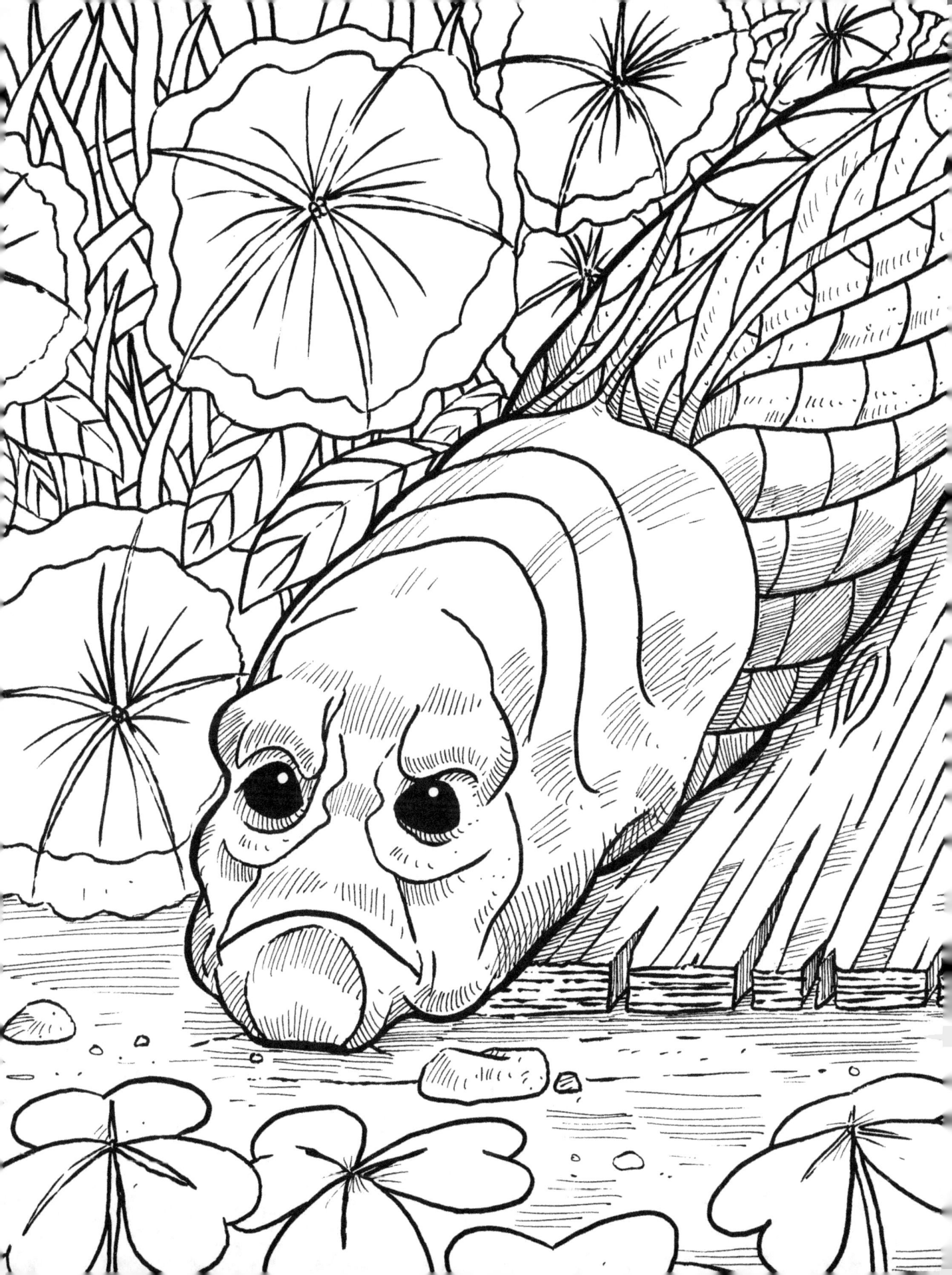

FREAKY FLIES

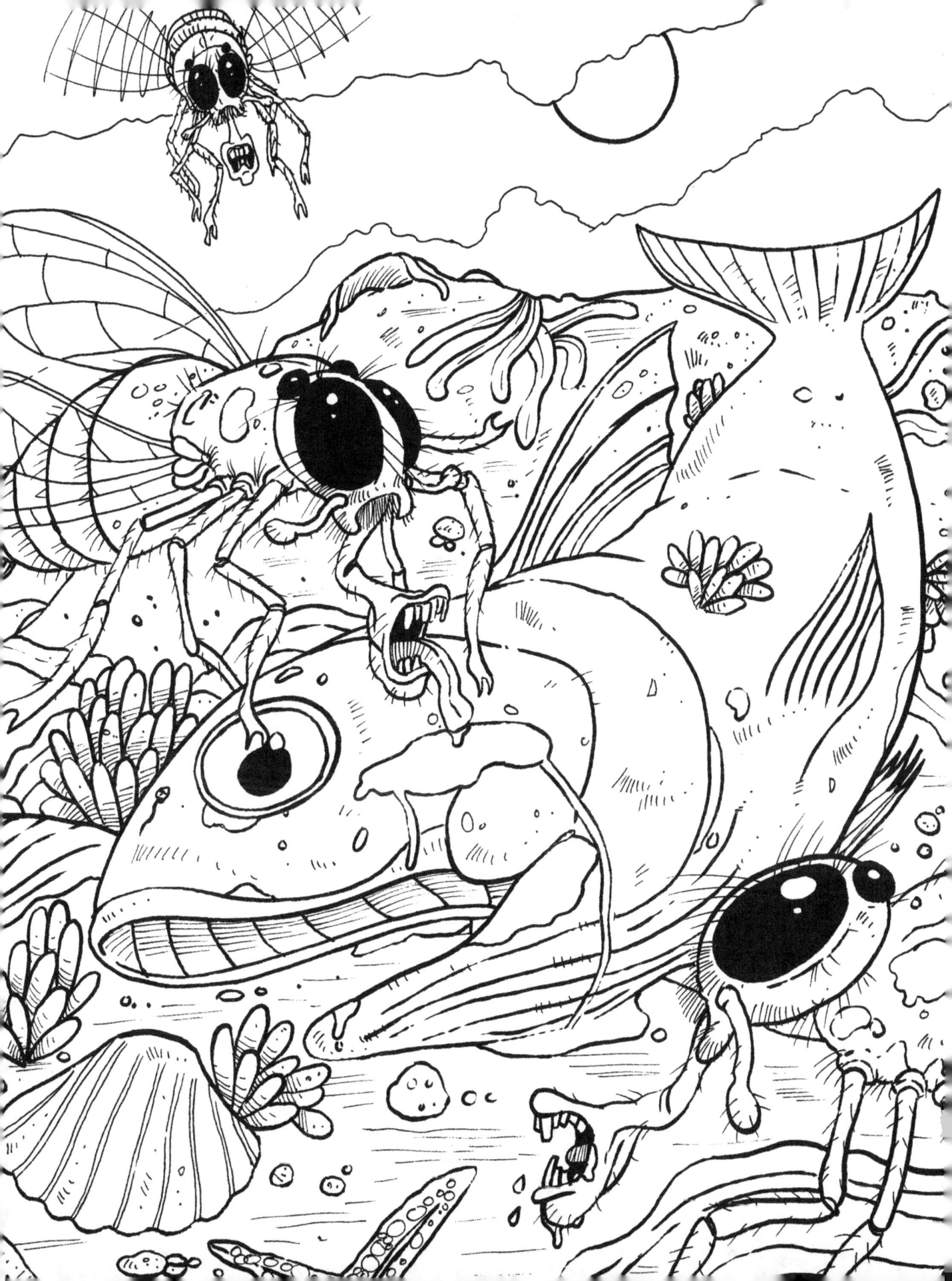

MANKY MAGGOTS

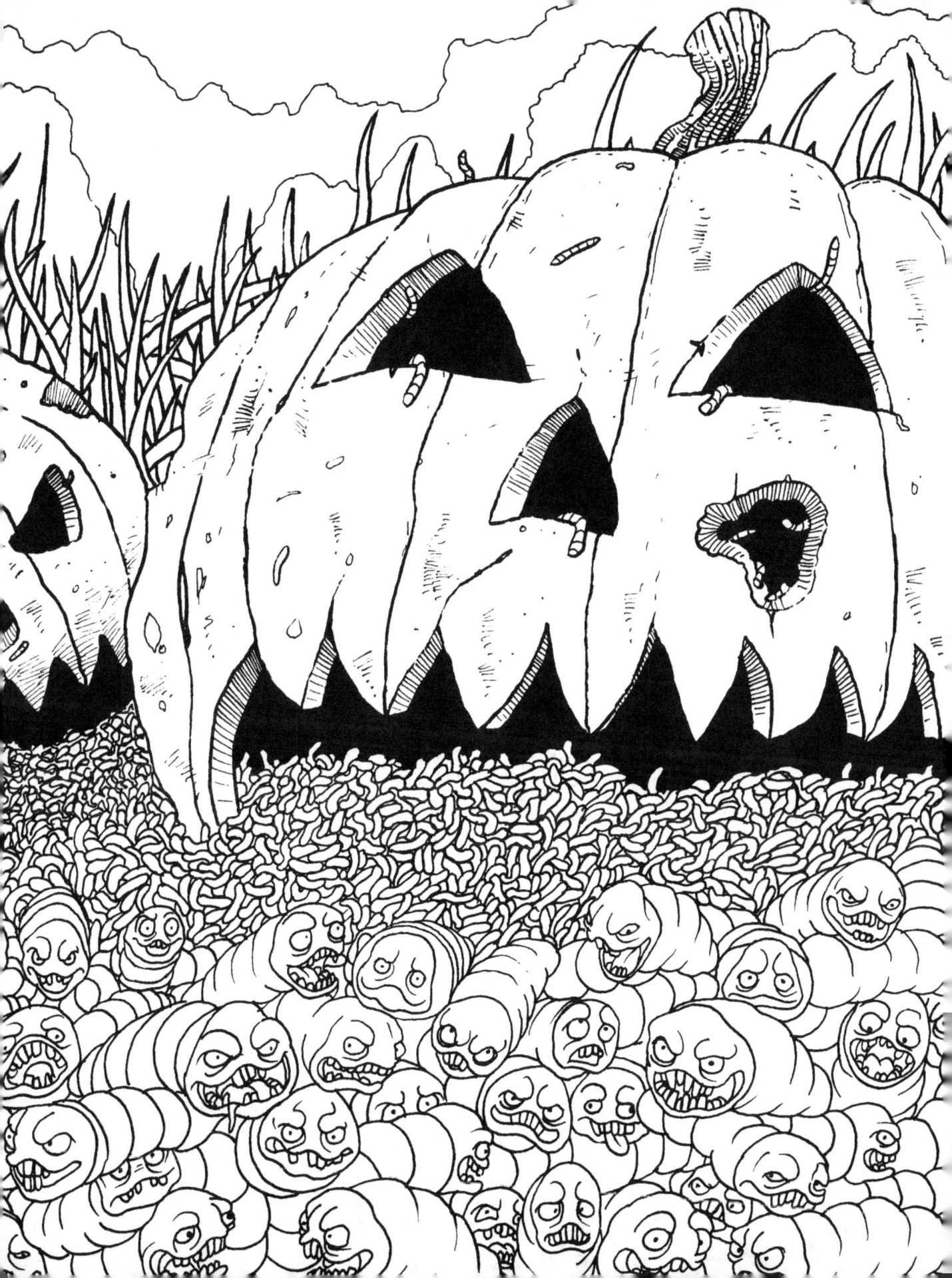

TANTRUMING TERMITES

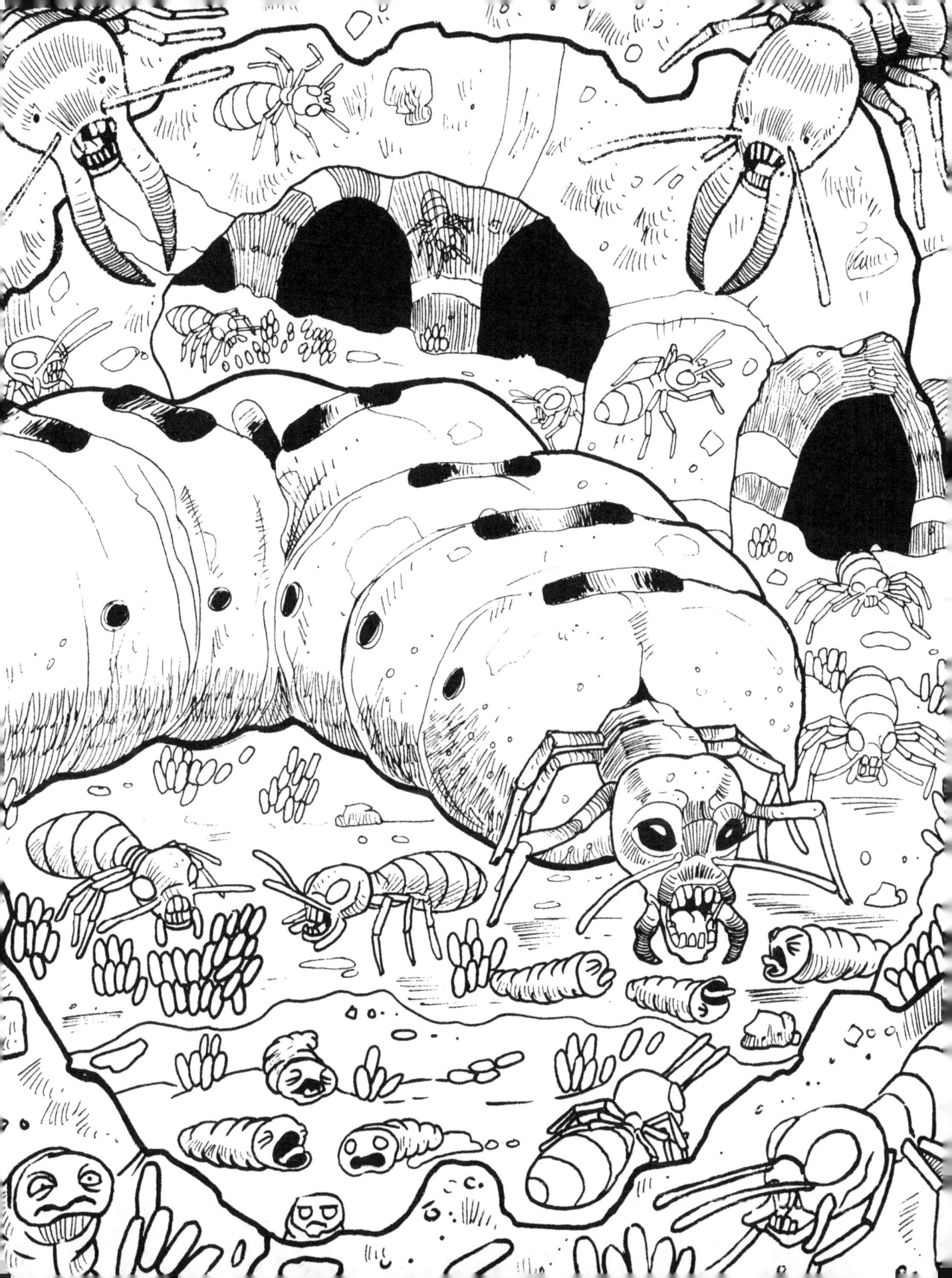

BOORISH BEETLES

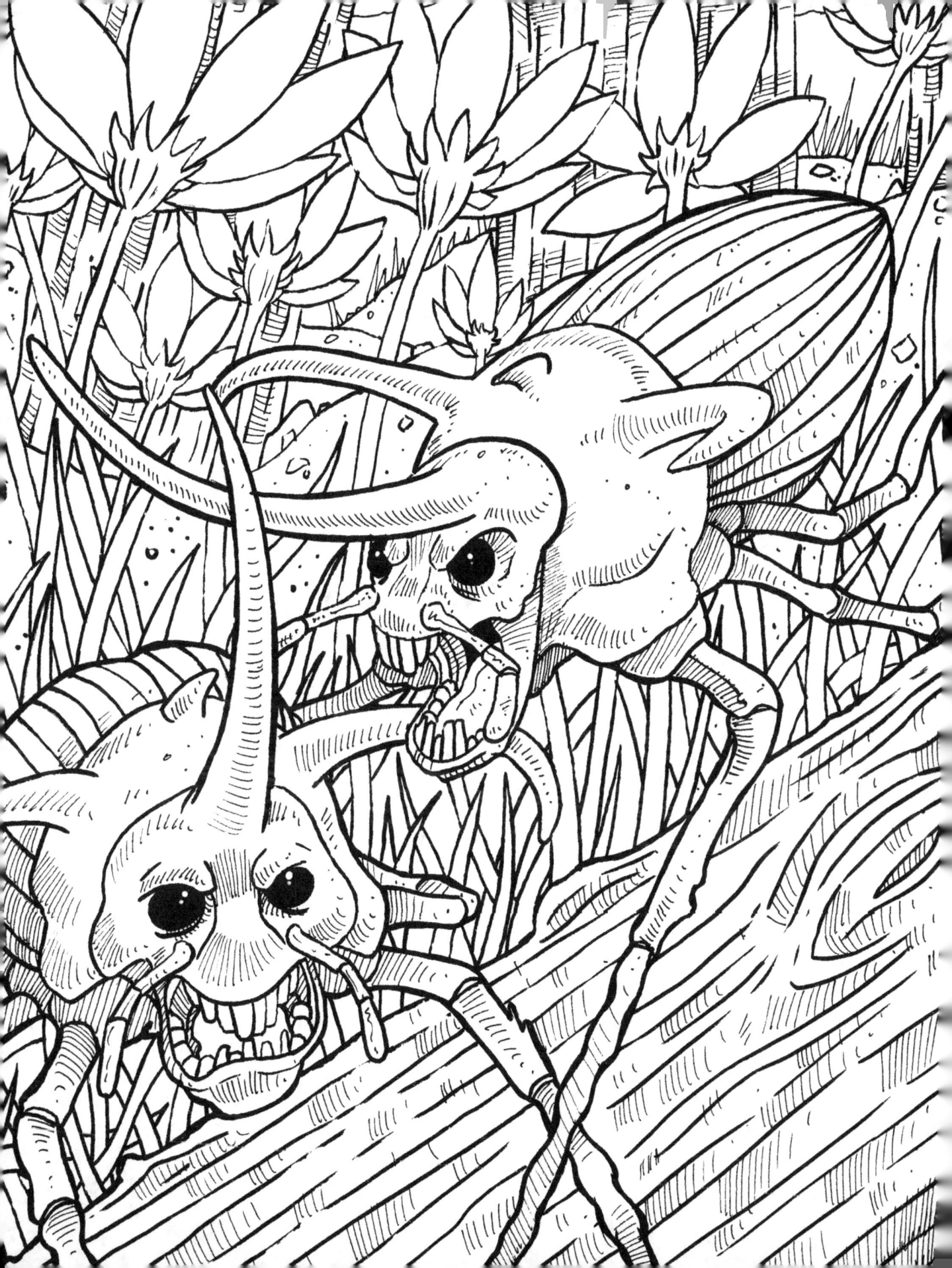

CREEPY CRYSALIS

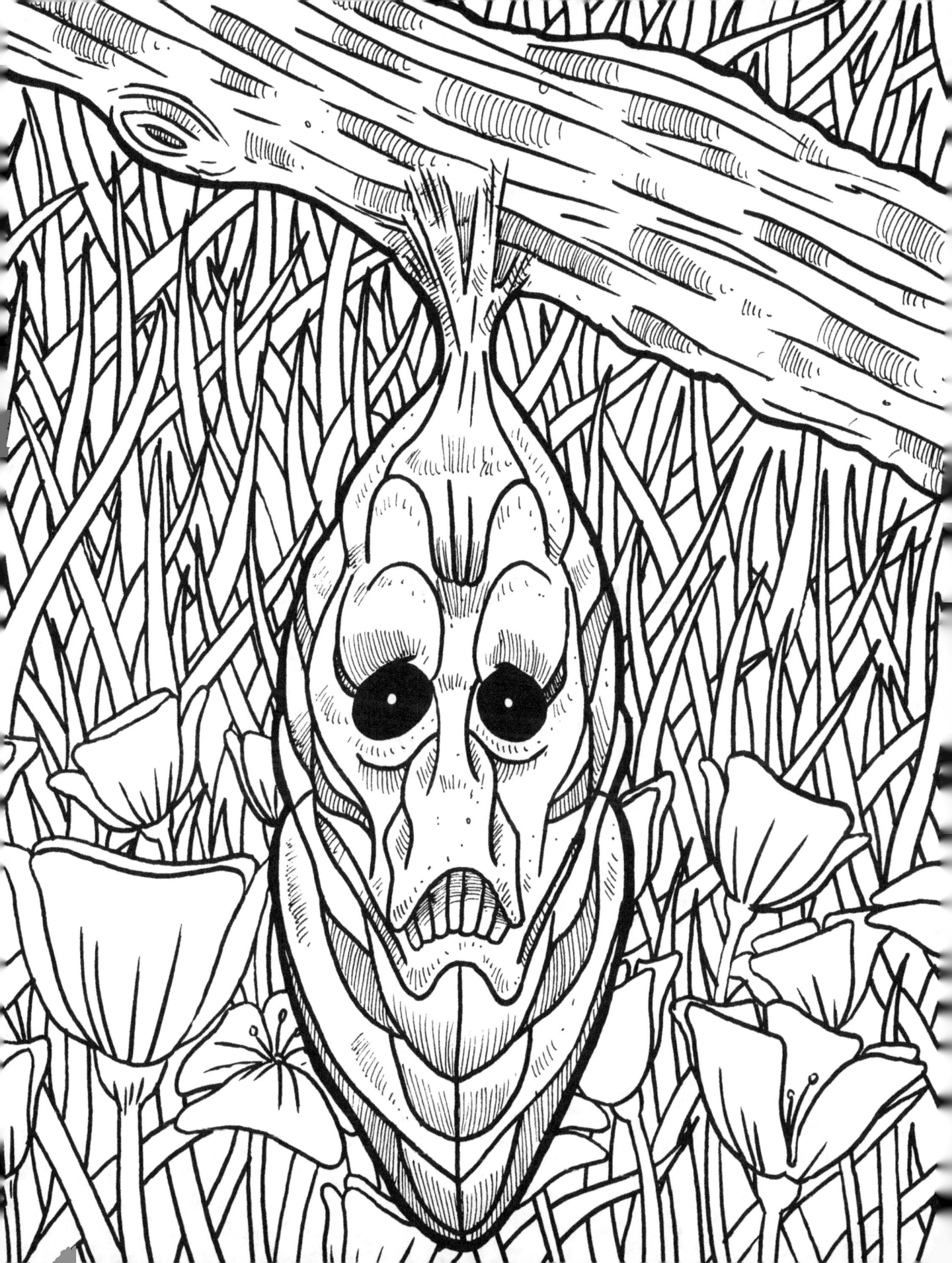

GLUTTONOUS GLOW WORM

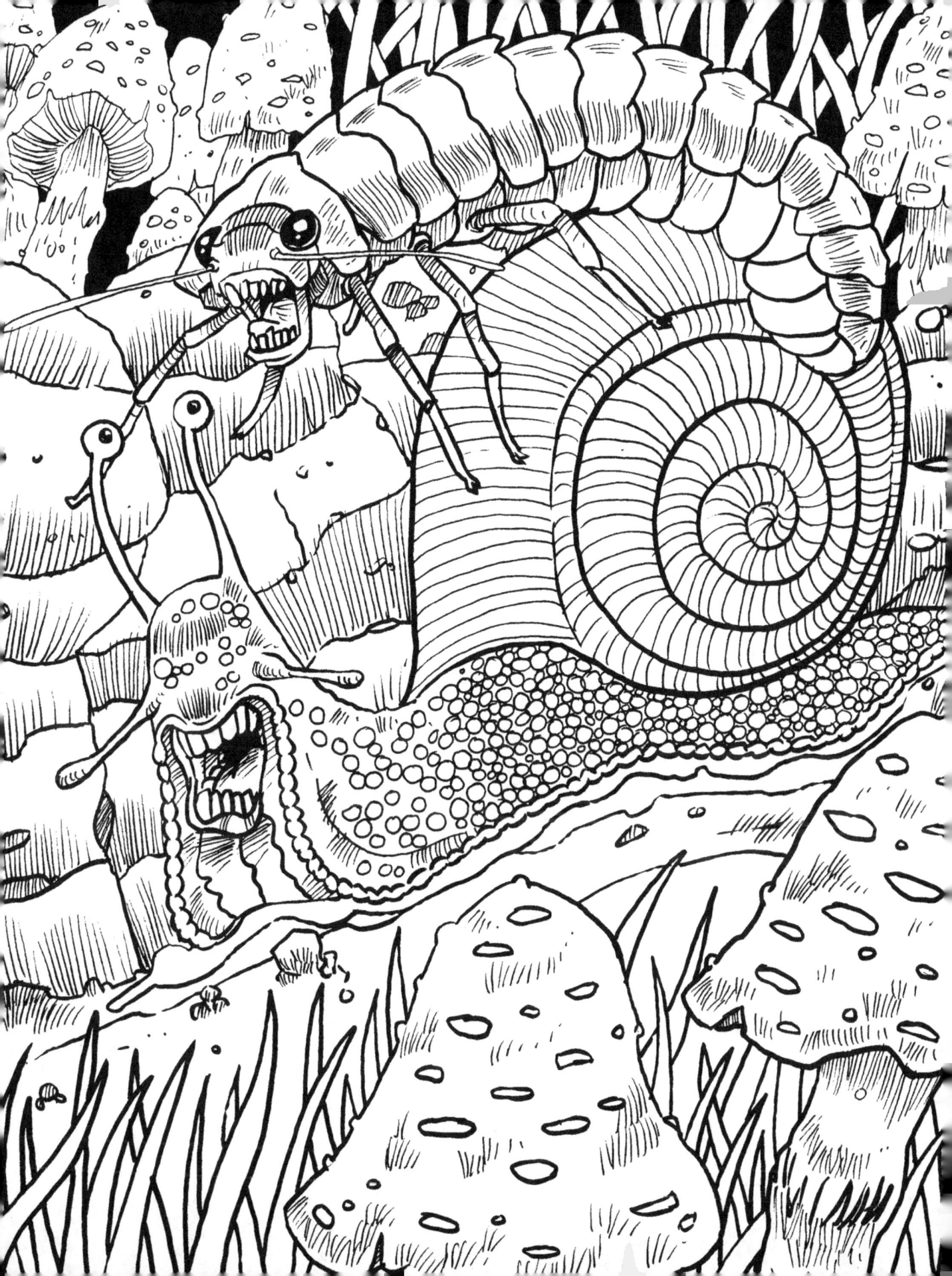

MUSTY MOTH

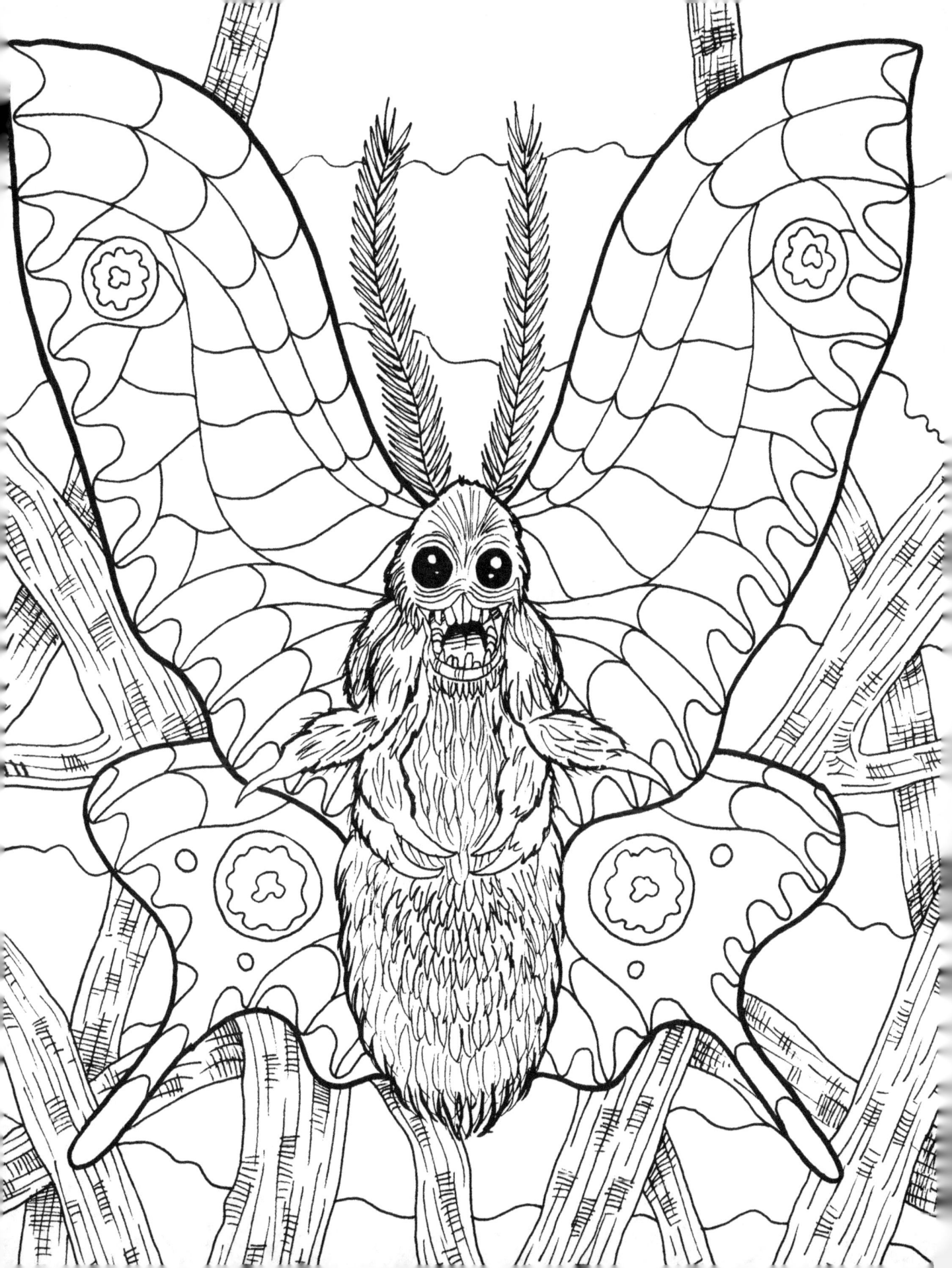

BULBOUS BUTTERFLY

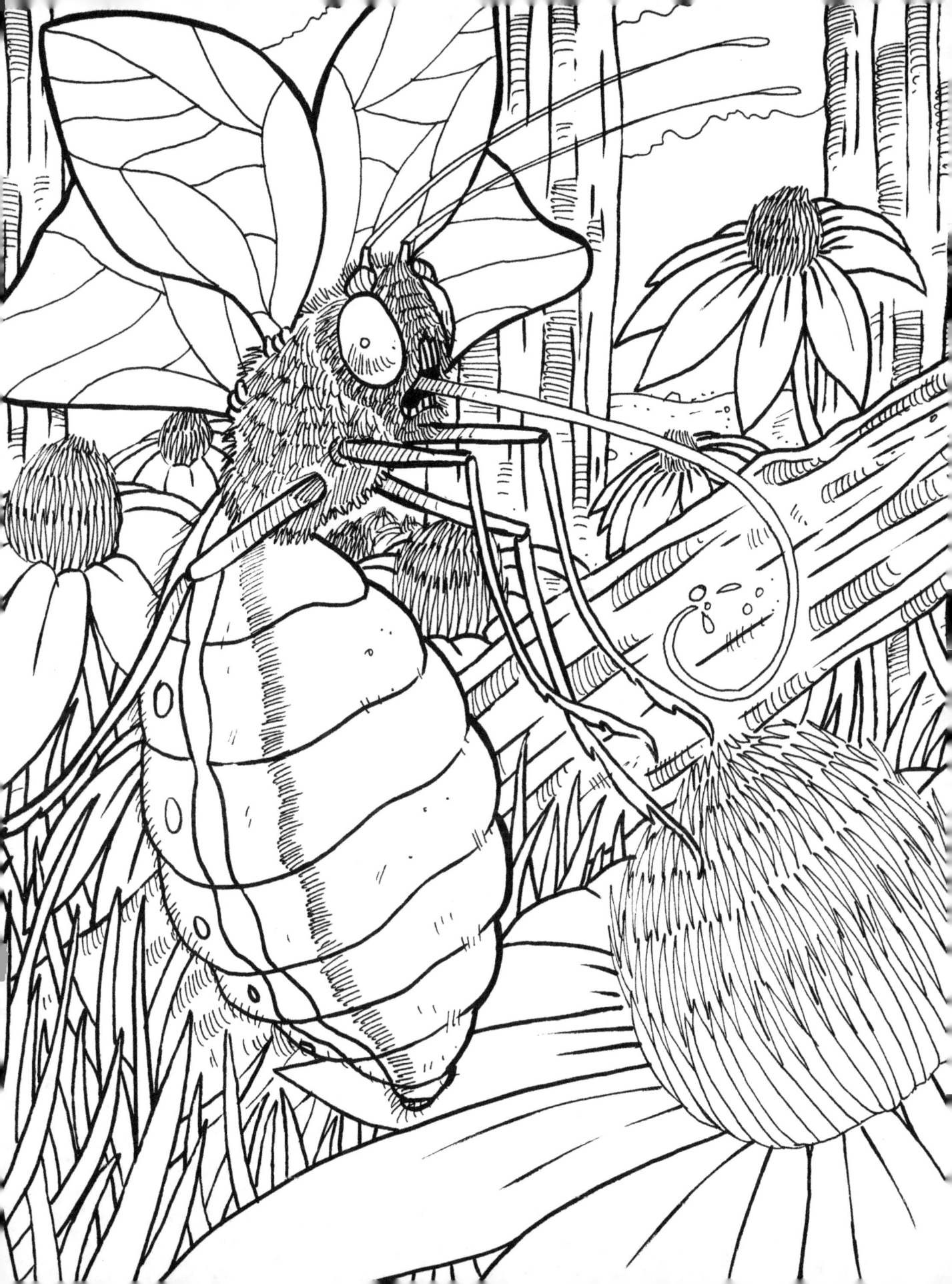

DARING DRAGONFLY

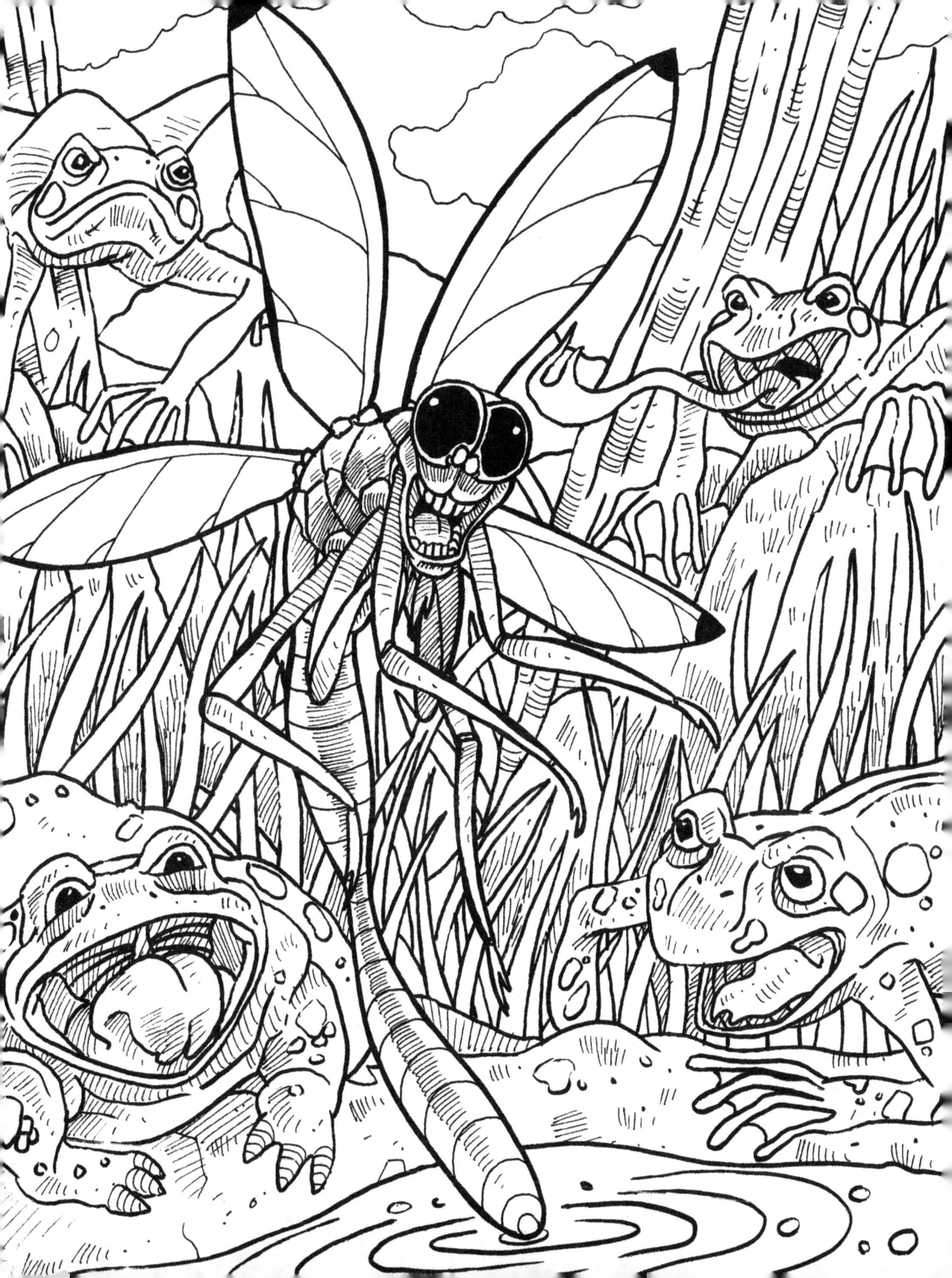

LETHAL LADYBIRDS

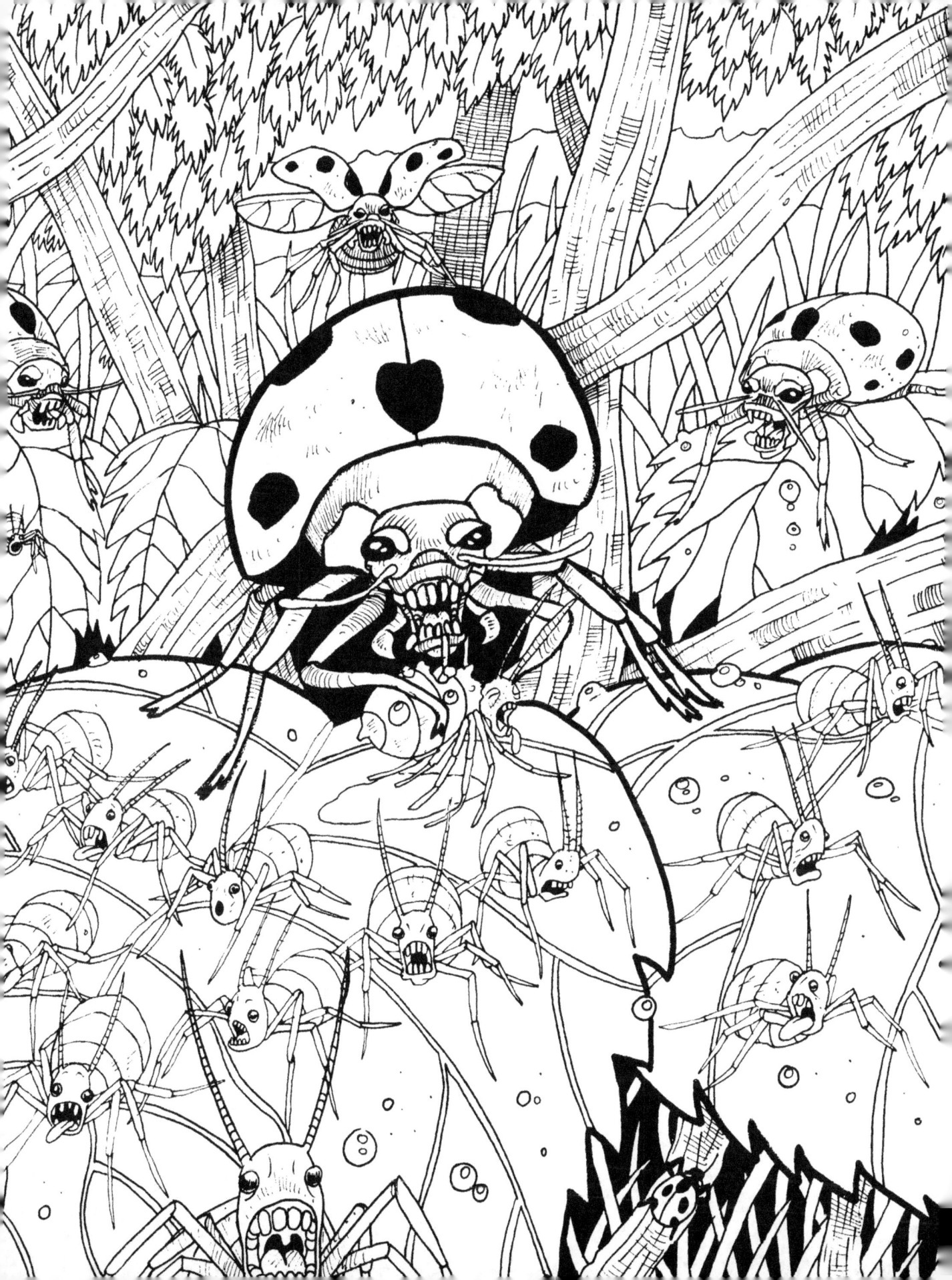

PETULANT PUPAE

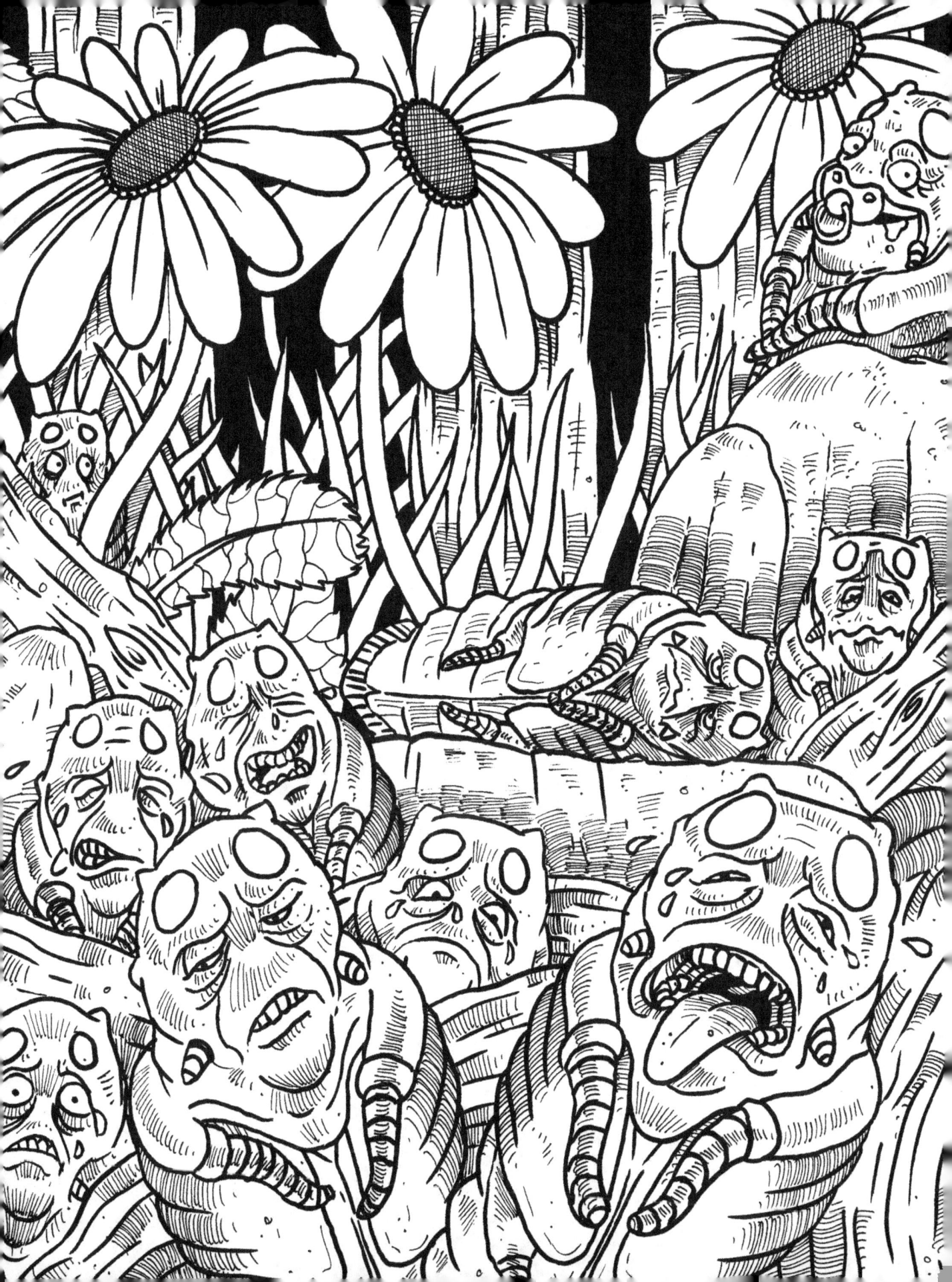

WICKED WASP

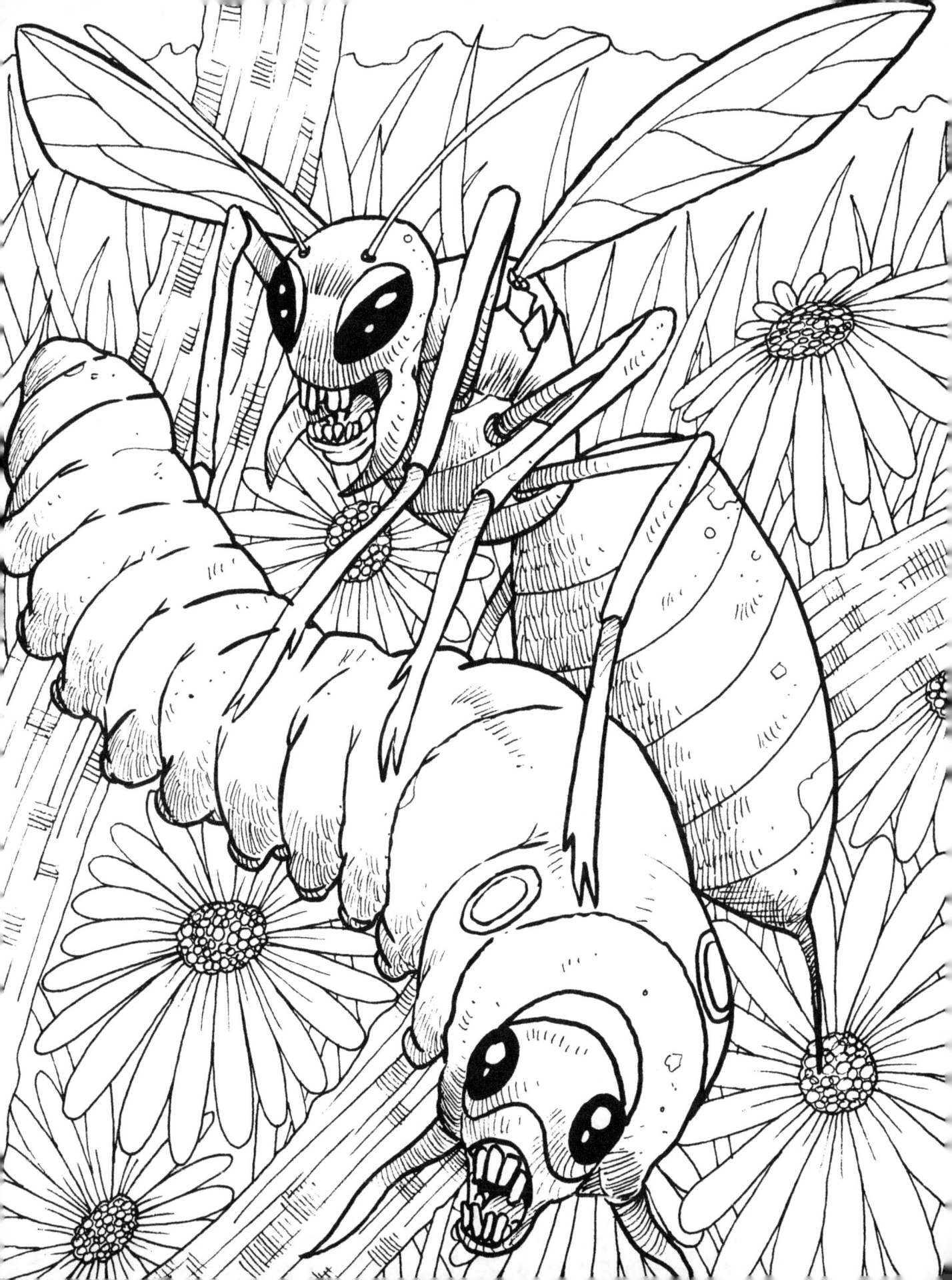

CANKEROUS CATERPILLAR

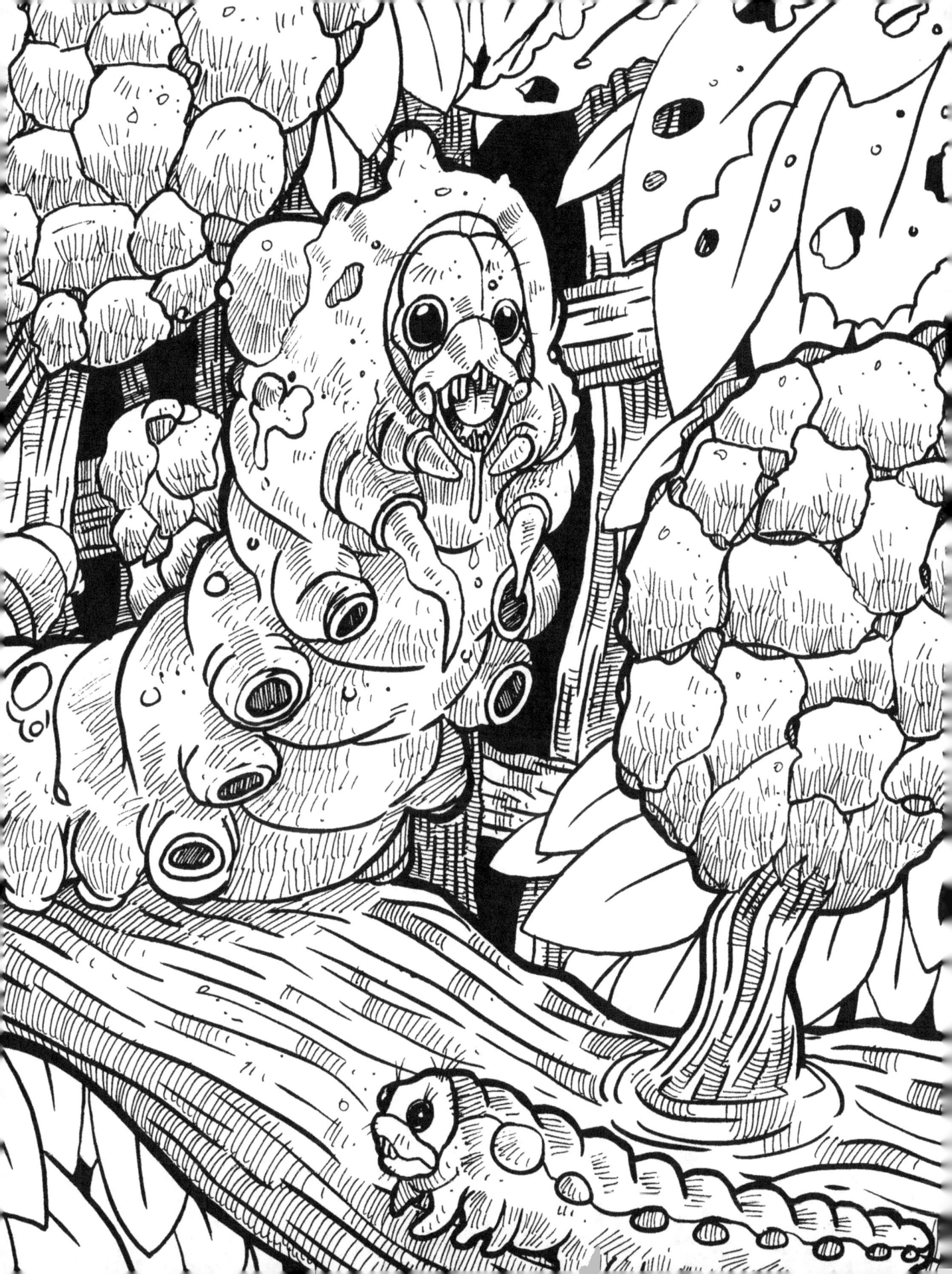

DIRTY DUST MITE

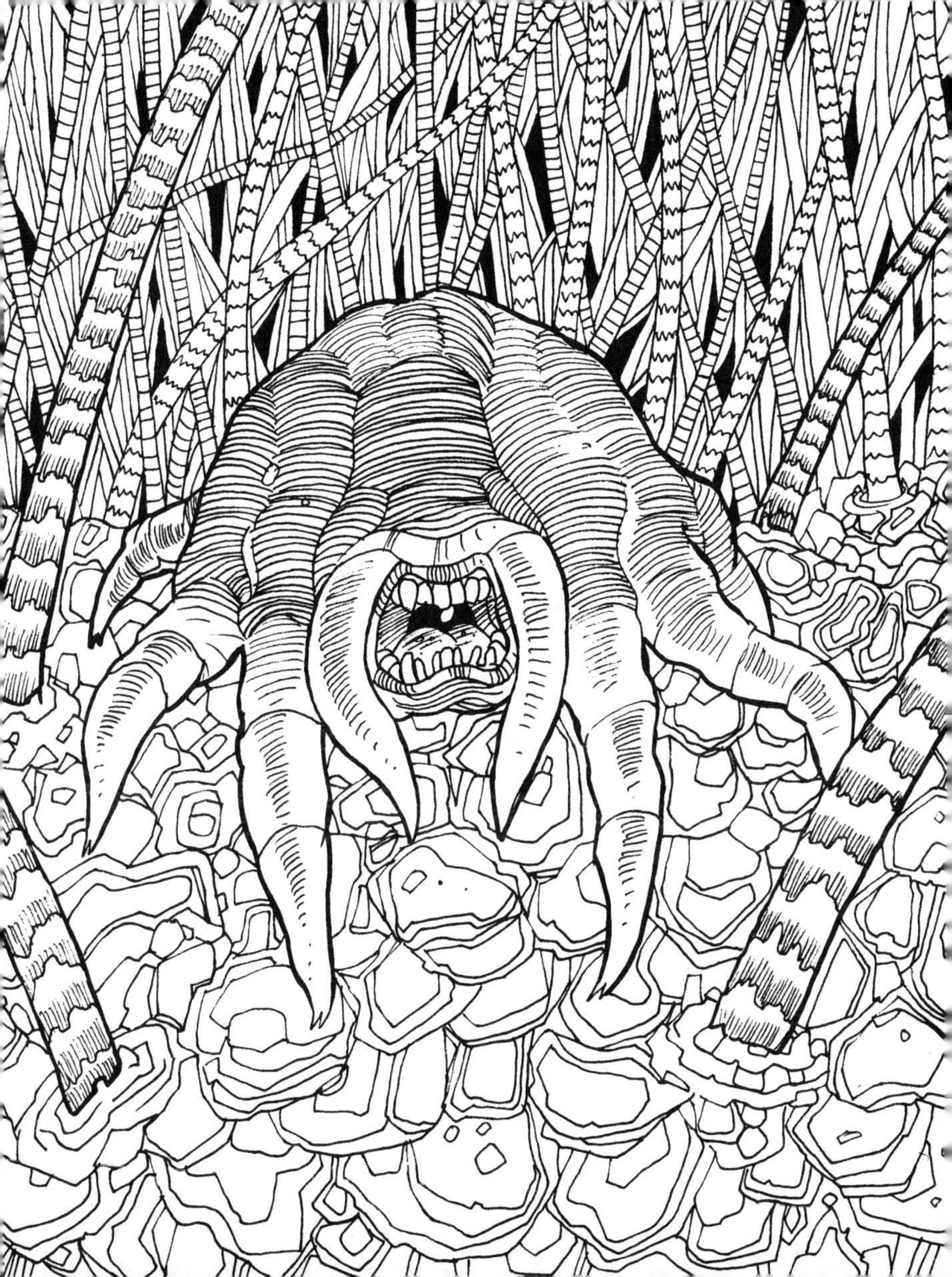

AFFLICTED ANTS

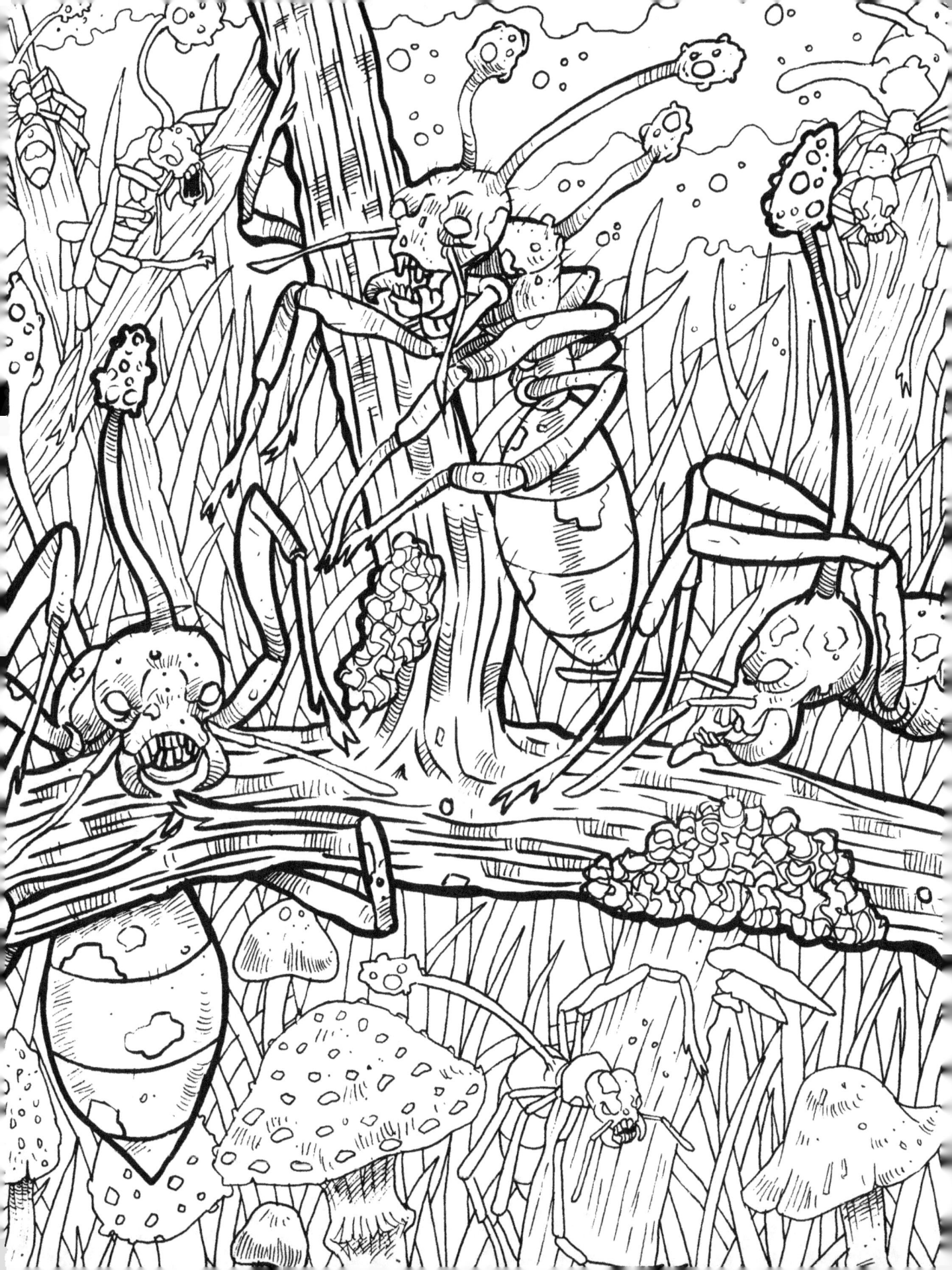

SICK CENTIPEDE

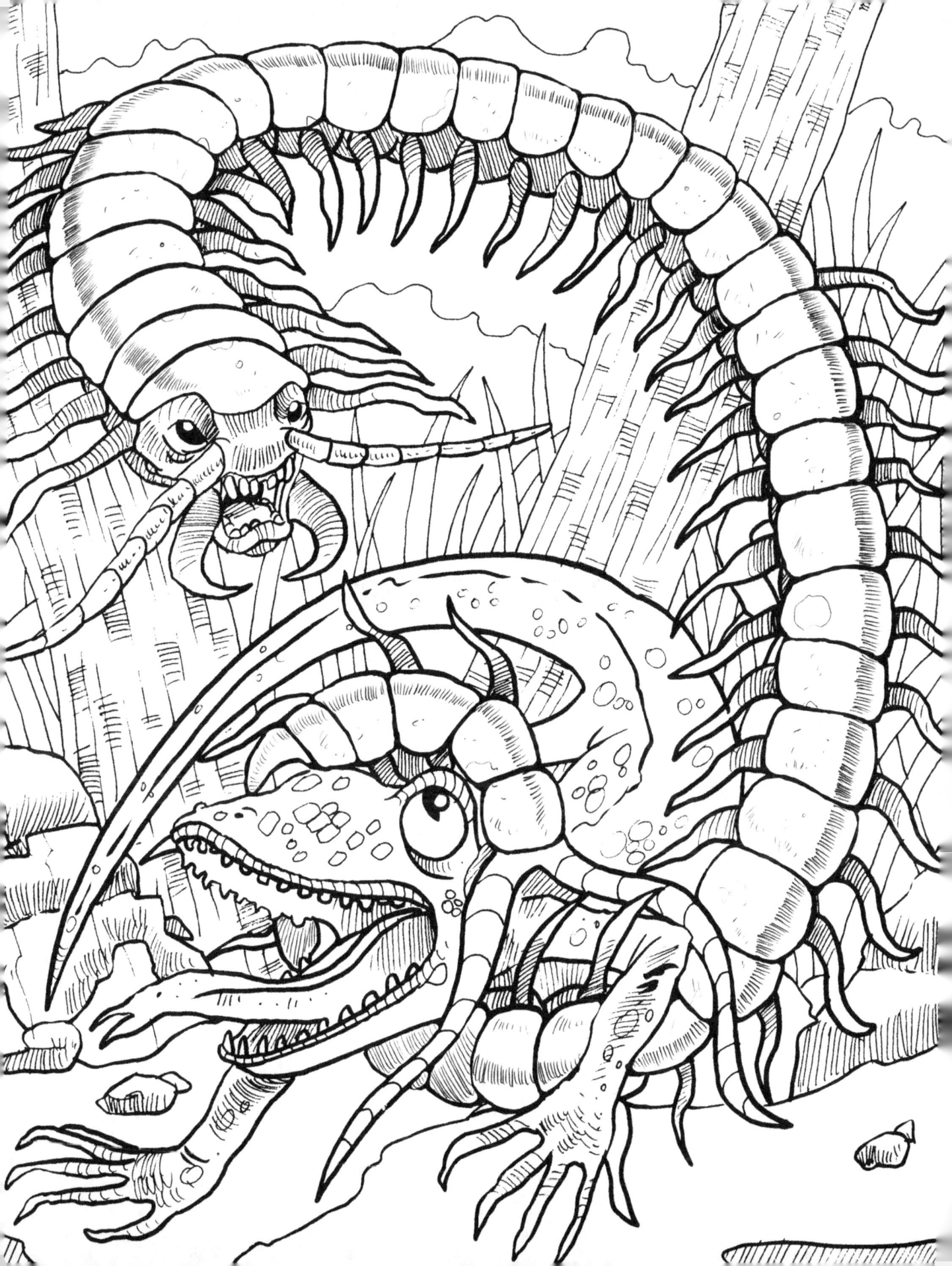

WONKY WEEVILS

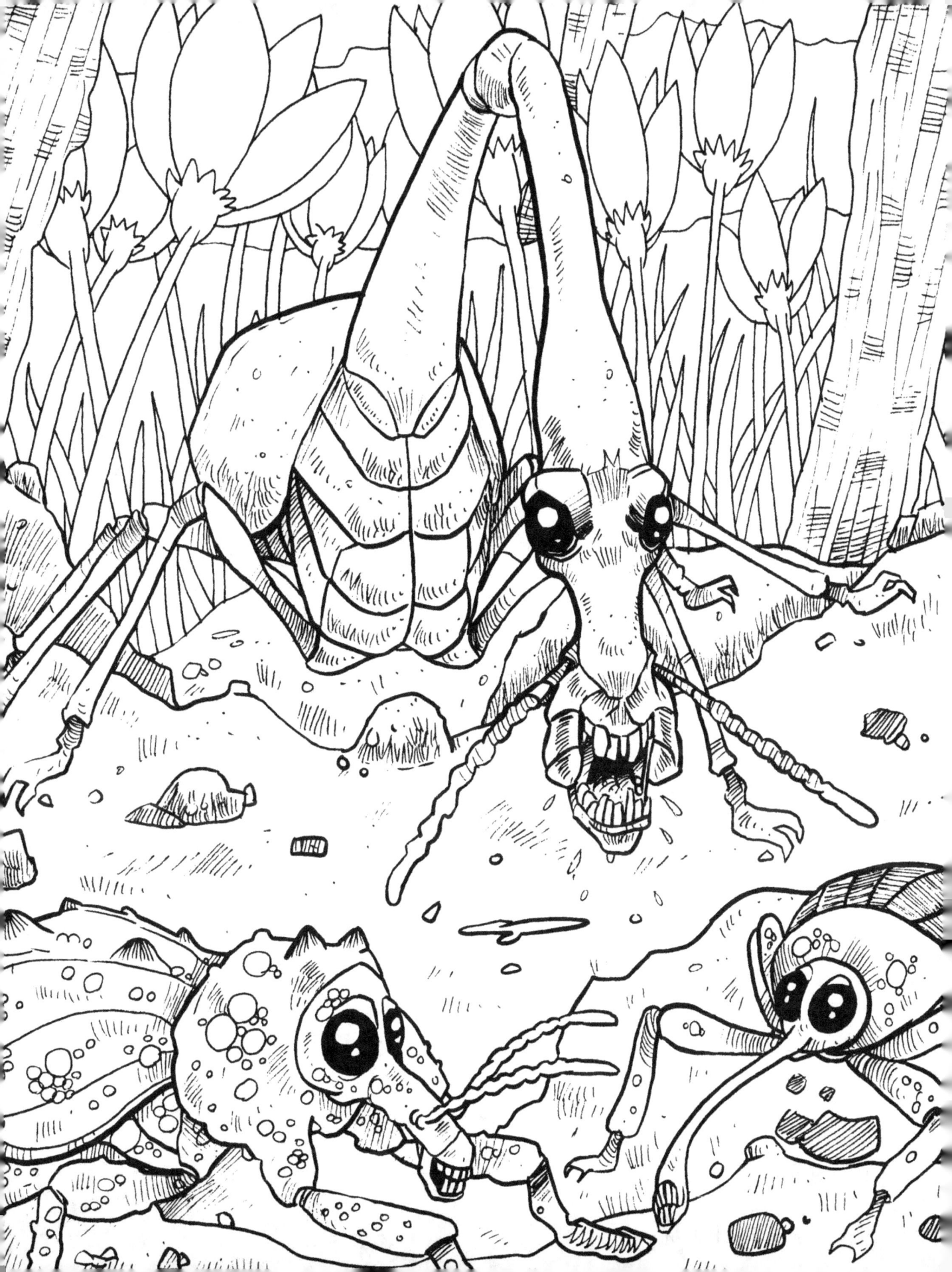